A.J. MacGregor

GRAPHICS SIMPLIFIED

How to plan and prepare effective charts, graphs, illustrations, and other visual aids

UNIVERSITY OF TORONTO PRESS Toronto Buffalo London

© University of Toronto Press 1979
Toronto Buffalo London
Printed in Canada

Chapters 1–4 originally were published as a series of articles in *Scholarly Publishing: A Journal for Authors and Publishers* © University of Toronto Press 1977, 1978

Library of Congress Cataloguing in Publication Data

MacGregor, Anette Jean 1939–
 Graphics simplified

Includes index.
1. Graphic arts – Technique. I. Title.
NC1000.M3 741.6 79-10358
ISBN 0-8020-6363-2 pbk.

Contents

Introduction

These notes have been written to fill a real need at my own university. Too often, scientists and teachers are simply not aware that the visual material they use in teaching and publication is, in fact, unintelligible and misleading. Too often, because of illegible graphics, a carefully prepared lecture degenerates into an incoherent ramble, or a paper becomes far more difficult than necessary to follow. The audience (or reader) naturally loses attention and becomes bored.

Yet well-planned, carefully designed visual material can greatly enhance a lecture or paper. Surely, to the myopic student in the last row, or to the scholar fighting the flood of publications, a simple line chart is more meaningful and more easily assimilated than multiple columns of minute figures. Five simple one-idea illustrations in a series are more easily understood than one which is over-crowded and hard to read.

Graphics Simplified was written as a concise, no-nonsense guide to the preparation of legible teaching graphics. It is intended to provide the information needed about when to use and how to design charts and graphs, how to achieve legibility, how to prepare graphics for specific media, and how to use various types of graphic aids to make the job easier. While it is directed to the teacher or scientist who must prepare his own teaching material, I hope that professional artists or photographers will also find it useful.

I wish to express my sincere gratitude to all who have helped me in the production of this book. Dr Sergey Fedoroff of the University of Saskatchewan gave me the original idea and much encouragement; Dr Rae Laurenson of the University of Calgary spent many hours reviewing first drafts and offering helpful criticism; Dr Charles Bidwell of the University of Alberta and Joe Connor of the University of Manitoba also gave helpful suggestions. I am grateful for the assistance given by these people and trust the result justifies their faith.

1

Charts and graphs

A mass of figures, even when most neatly arranged in columns and tables, only reluctantly reveals its secrets, even after considerable study. That is why we turn to charts and graphs, and use them to highlight trends and illustrate comparisons implicit in the raw data. Charts and graphs are a means to present statistical information clearly and accurately, and to do this they must be kept as simple and straightforward as possible. The objective of the graphic designer is a superb balance between simplicity and function. The successful product is accurate, clear, concise, and elegant.

There are many types of charts and graphs, and each has its own purpose. The principal ones are described in this chapter. Arithmetic line or curve charts show trends or movements over time. Column charts compare magnitudes or emphasize differences, also over time. Bar charts are used to compare magnitude or size of different items at the same time. Pie charts, particularly useful to the lay audience, and 100% column charts show relations of component parts of a whole. The more complex semi-logarithmic charts show relative changes and are useful when quantities are vastly different. Frequency distribution charts are specially designed to show patterns of occurrence. Sometimes, instead of abstract lines and bars, symbols can be used to make charts more attractive or to communicate abstract ideas. In every case, the selection of a particular kind of graphic representation is as important as the care with which it is rendered.

Line or curve charts depict trend or
movement over a period of time.
Time, or any other independent vari-
able – that which changes regularly –
is plotted on the horizontal axis; the
dependent variable – that which
changes irregularly – on the vertical
axis.

When to use
To show trend or movement rather
than actual amounts.
To illustrate long series of data.
To compare several series of data.
To interpolate or extrapolate.

When not to use
When the emphasis is on change in
amounts rather than on movement or
trend. Instead, use the semi-
logarithmic chart.
To compare relative size or to em-
phasize difference between elements.
Instead, use the bar or column chart.

Positive and negative values
To show percentage or other devia-
tions from a norm. Quadrants I and IV
are used. (This will be discussed in the
next chapter.) The zero base line rep-
resents the mean, the curve repre-
sents deviations from this mean. Note
that the x (the zero base line) and the y
axes are the same width.

8

Special referent line
To compare trend of data with an index. The referent line is the same width as the x axis.

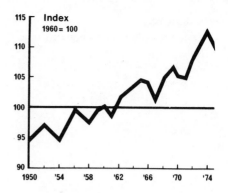

Surface or silhouette
To emphasize or dramatize trend. The arithmetic curve is filled in.

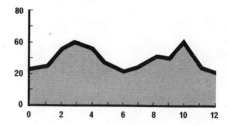

Multiple surface or band
To compare trend of a whole and its components. This is *not* an arithmetic line chart filled in. The width of each band expresses a unique value. Only the topmost line is the total of all values. Place the curve with the least movement next to the horizontal axis, the second smoothest curve next, and so on for no more than five curves. Do not use this chart when movement of curves is erratic. A divided or grouped column chart can illustrate the same information, as can the simple arithmetic chart.

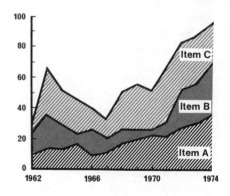

9

100% surface
To portray trend of components of a
whole.

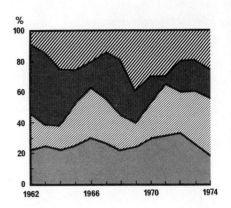

2/ COLUMN CHARTS

Column charts are simple and adapta-
ble and are readily understood by the
lay audience. They are interchange-
able with the arithmetic line chart.

When to use
To compare magnitude or size or to
emphasize difference in one item at
various periods of time.

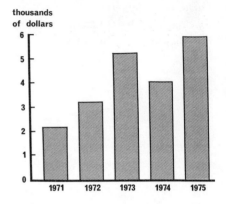

When not to use
To illustrate *trend* of data. Instead,
use the arithmetic line chart.

Grouped column chart
To compare independent series of data
over a period of time. Limit the
number of bars in one group to three.

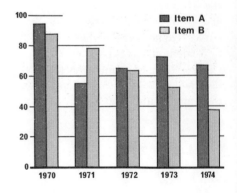

Subdivided column chart
To compare totals and sums of totals over a period of time. Because the upper segments do not have a common base line, they are hard to compare.

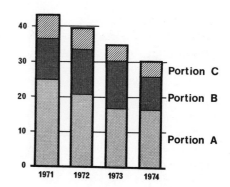

Deviation column
To portray positive and negative values over a period of time.

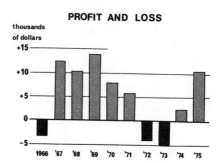

100% column chart
To compare components of a whole at one time. This is not a time series. Keep the portion of most interest next to the base line. Lines connecting the sections facilitate comparison.

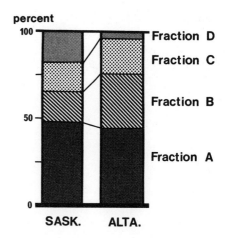

3/ BAR CHART

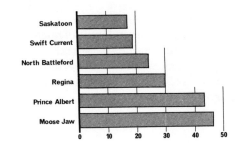

Bar charts are simple, adaptable, and readily understood by the lay audience.

When to use
To compare magnitude or size or to emphasize difference between many items at one specified time.

When not to use
To compare difference in size of one item over a period of time.

Grouped bar
To compare various aspects of several items at the same time.

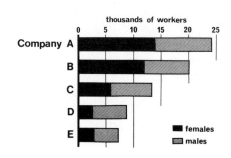

Subdivided bar
To compare totals and sums of totals at one time.

100% bar
To compare components of a whole.

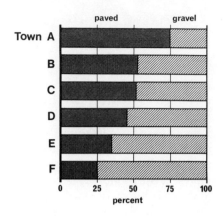

Paired bar
To compare two different types of data.

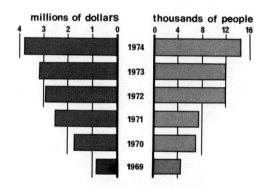

Deviation bar
To portray positive and negative values at one time. Arrange bars in descending order where possible.

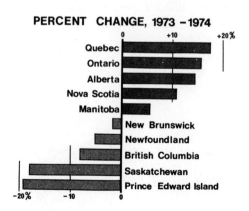

4/ SEMI-LOGARITHMIC (RELATIVE CHANGE) CHARTS

This type of chart, portraying proportional and percentage relationships, is useful because both relative changes and absolute amounts are shown. Relative change for large and small quantities can be compared. In the arithmetic line chart, equal spaces represent equal *amounts* of change; in the semi-log chart, equal spaces represent equal amounts of relative change.

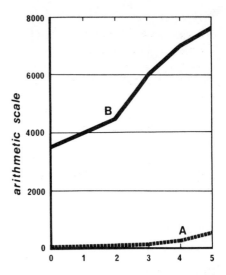

When to use
To show relative change when baseline quantities differ greatly. The arithmetic chart portrays comparative fluctuations only when the quantities compared have similar values. These two graphs represent the same data. On the arithmetic chart, line B appears to be growing very much faster than line A. On the semi-logarithmic chart, however, it can be seen that, although line B has actual amounts far in excess of line A, line A is, in fact, increasing much faster relative to the baseline quantity.

To compare relative change of variables expressed in different units, e.g., miles of street lighting vs population.

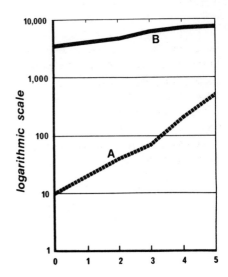

When not to use
To compare *amounts* of widely separated values.
To illustrate data for the lay audience.

Preparation

A logarithm is the power to which 10 must be raised to produce a given number. In the equation $10^2 = 100$, the figure 2 is the logarithm, 100 is the anti-logarithm.

$$10^0 = 1 \qquad 10^{0.90309} = 8$$
$$10^{0.30103} = 2 \qquad 10^{0.95424} = 9$$
$$10^{0.47712} = 3 \qquad 10^{1.0} = 10$$
$$10^{0.60206} = 4 \qquad 10^{1.30103} = 20$$
$$10^{0.69897} = 5 \qquad 10^{1.47712} = 30$$
$$10^{0.77815} = 6 \qquad 10^{2.0} = 100$$
$$10^{0.84510} = 7$$

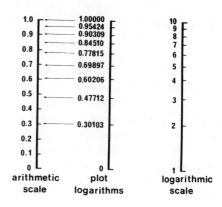

arithmetic scale plot logarithms logarithmic scale

On the semi-logarithmic chart, the vertical axis has logarithmic divisions and the horizontal axis has arithmetic divisions. On full logarithmic charts, both x and y axes are divided logarithmically.

Semi-log paper is available, pre-ruled, with 1, 2, 3, or more cycles or banks. One cycle starts at 1 and ends at the next 1. Note that there is no zero. For this reason, the ordinate axis does not have to start at zero, but can begin at any convenient value.

Paper of specific measurements can be prepared.

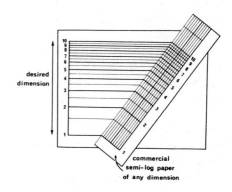

desired dimension

commercial semi-log paper of any dimension

How to read semi-logarithmic charts
Vertical distance on a semi-
logarithmic chart indicates a percen-
tage change. The space between 1 and
2 (or between 10 and 20 or 100 and
200) always represents a change of
100%. This same distance *always*
represents a change of 100%, no mat-
ter where in the chart it is measured.

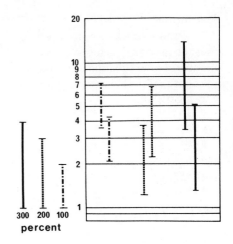

Thus, curve A increased by 100% be-
tween 1968 and 1970. Between 1970
and 1974 it increased by another
100%. Curve B, having a steeper gra-
dient, increased by 100% between
1968 and 1969 and again between
1969 and 1972 and 1972 and 1974.

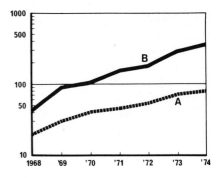

16

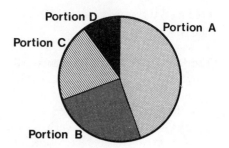

Like the 100% column chart, the pie chart portrays relations of component parts. In the pie, however, it is difficult to compare areas accurately.

When to use
To show relations of component parts, especially to the lay audience. Two other graphs, the 100% bar or column and the simple bar, will portray the same data.

When not to use
To compare component parts of two or more wholes. Instead, use 100% column charts.

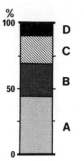

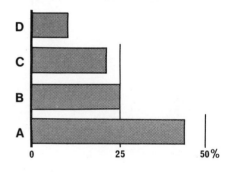

6/ FREQUENCY DISTRIBUTION CHARTS

The difference between frequency distribution and arithmetic line charts is in the data portrayed. Discontinuous variables, those with a limited number of distinct values, such as numbers of people, are plotted against continuous variables, such as age, weight, salary, etc., which have an unlimited number of possible values. The latter are usually placed on the x axis.

When to use
To visualize the distribution of various entities.

Preparation
Three types of frequency distribution charts exist and can be prepared from the same data: histogram, polygon, and smoothed curve.

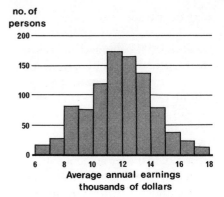

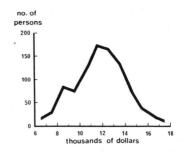

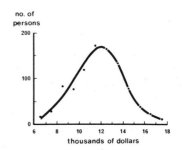

Age and sex pyramid
This is a special application of the frequency distribution chart. The distribution of two sets of data is compared. Age, the continuous variable, is plotted on the vertical axis. Numbers of both males and females within each group are now placed on the horizontal axis.

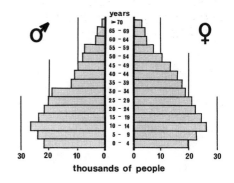

18

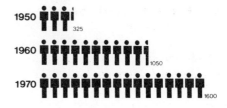

Pictorial symbols can facilitate the communication of abstract ideas or concepts. Symbols not only have great audience appeal; they also afford a wider latitude of expression in a nearly universal language.

Symbols can be used in two ways: As numerical counting units: each symbol represents a specific number. As a support for a conventional chart form: symbols add emphasis and differentiate.

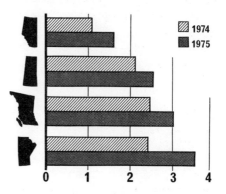

How to use pictorial symbols
Symbols must have strong associations with the idea so that they are readily understood by the audience. Avoid dated or regional symbols. Symbols must be well designed and simple. They must be recognizable on reduction or enlargement and should be easily divisible. Shapes *must* contrast well. Never rely on 'tags' for identification of symbols.

YES!

NO!

19

When used as counting units, symbols must all have the same value and should all be approximately the same size.

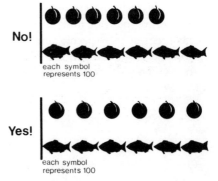

No!

each symbol
represents 100

Yes!

each symbol
represents 100

In quantitative data, avoid comparison of *size* of symbol. It is practically impossible either to draw or visually compare symbols whose volumes vary.

To change only one dimension, e.g., height, is ludicrous. Instead, change the number of symbols.

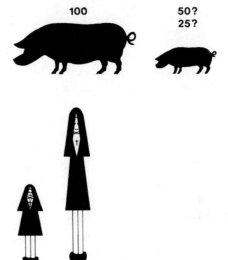

100

50?
25?

2

Preparing charts and graphs

Here are some preliminary considerations in planning the design of charts and graphs:

What medium is to be used – print (in a book or in a journal which may have its own rules for style), television, 35 mm slides, overhead projection, etc? The limitations of each medium will define the size and shape of the artwork, the size and number of words that may be included, the width of lines, tone patterns, and so on. Some of these matters will be discussed in the third chapter.

What is the graph intended to stress – trend, magnitude, rate of change? The answer to this suggests the type of graph to be used.

What audience is expected or intended? How big is it? What is its background? What does it want to learn?

Is the graphic to stand alone or as part of a group? Graphics in a series should be prepared in the same size so that all words, lines, and other elements will end up in a uniform size on publication or projection.

In general, plan ahead so that all graphics in a series will be consistent in colour, style, and appearance. Any one chart or graph in a series can be emphasized by a change in colour or format.

Rectangular co-ordinate surface

A rectangular co-ordinate surface is used to illustrate how changes in one amount relate to changes in another amount. All time series charts – arithmetic line, semi-logarithmic, column, and frequency distribution – are prepared on this co-ordinate surface, usually in Quadrant I.

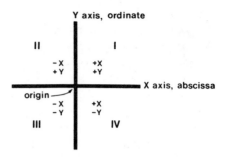

Rectangular coordinate surface

Title

Use the largest size of lettering for the title. Usually it is centred at the top or bottom of the grid. The title must tell what, where, and when. It should be as short as possible: eliminate unnecessary words.

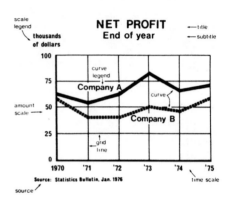

Axes

Axes should be heavier than the grid lines, but not as heavy as the curves. The Y axis can be replaced by horizontal grid lines.

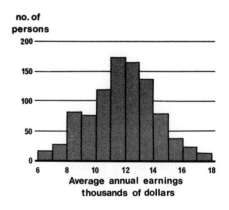

Amount scale

On all arithmetic line, bar and column, and frequency distribution charts, the amount scale must start at zero. Not to do so creates visual distortion of the truth. Always write in the zero. On the other hand, a zero base line is not necessary in charts based on an index, e.g., cost of living index. Semi-logarithmic charts can start at any convenient value.

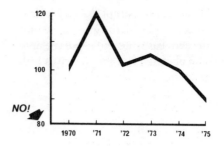

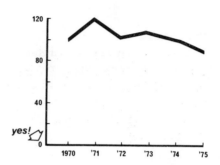

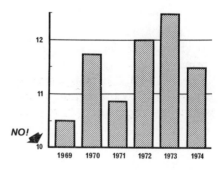

When a large part of the grid is un-necessary, break the grid but retain the zero base line and make the division obvious. Use this device as little as possible.

When necessary, two amount scales – but no more – may be used. Label each scale and its corresponding curve clearly. Colour coding can help avoid confusion.

Time scale
Even though data for a certain period are missing, time-scale divisions must always be equal. Use a dotted line to connect the curve over periods for which there are no data.

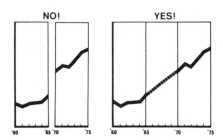

Scale legends and figures

Lettering is smaller than that of the title.

Legends should be concise and include the unit of measurement where necessary. The amount scale should be labelled horizontally directly over the amount numbers. If there are too many words, use italic parallel to the axis. The horizontal arrangement, although desirable, is not imperative for print.

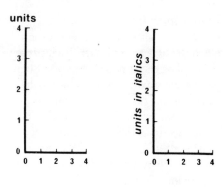

Figures should be placed at every second or fourth grid ruling. Use as few zeros as possible. State the number of units in the scale legend.

Use standard intervals, e.g. 10, 20, 30, rather than awkward ones.

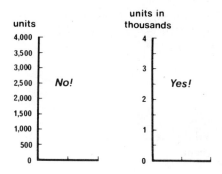

Grid lines

Grid lines may often be omitted. Indicate major divisions by small ticks and minor divisions by smaller ticks inside the scale lines.

When grid lines are necessary, draw them narrower than the axes. Eliminate all but those essential for easy reading.

There are no specific rules for determining the best grid proportions. Dramatic visual distortions can result merely by compression or extension. Be uniform throughout a series.

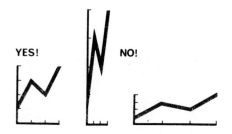

Curve lines

The curves should be the most prominent feature in any chart. Each curve should be about two times wider than the x and y axes. The weight will depend on the number of curves – the fewer, the wider. Each should be the same width as the others and have a distinct colour or pattern. If one curve is wider than the rest, it appears to be more important.

Do not show normally more than five curves on one chart. When there are many overlapping, crossing curves, enlarge the overcrowded portion of the grid or prepare more than one graph.

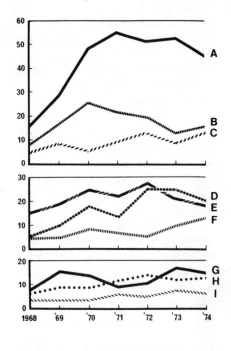

When lines cross, interrupt one of them.

On a very steep curve, it is usually best to round off the point.

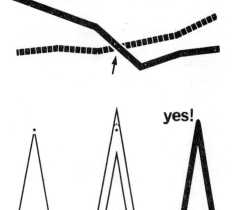

26

In published material, points are usually included and should be the same width as the curve line. Different shapes – circles, squares, and triangles – should be used rather than variations of one shape.

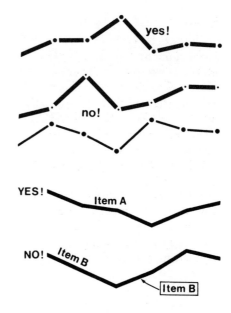

Curve legends
Place curve legends horizontally.
Avoid using leader lines and arrows where possible.
Do not box labels.
Interrupt grid lines where they are crossed by words.

Keys
Wherever possible, avoid using a key. Instead, label curves, bars, or columns directly.

When a key is necessary, place it where it will balance other elements in the chart.

Tones

For surface, bar, column, frequency distribution, or pie charts, use black and white tone patterns to differentiate areas. Let adjacent values contrast well. These seven commercially available patterns plus white and black are arranged in ascending order of tone or value or darkness.

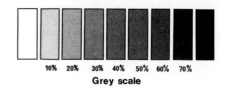

10% 20% 30% 40% 50% 60% 70%
Grey scale

Never place adjacent tones (i.e., 10% and 20% or 50% and 60%) side by side. Keep a contrast of at least 30% between tones, even though the patterns themselves are distinct.

Make the most important or the smallest bar the darkest and in strong contrast with the adjacent tones.

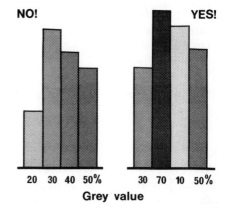

NO! YES!

20 30 40 50% 30 70 10 50%
Grey value

Optical illusions are often created by unwise choice and placement of patterns. Avoid this by keeping all striped patterns at a 45° angle to the base line and running from left to right.

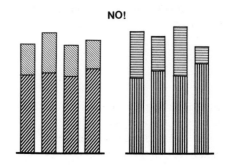

NO!

For publication, use a tone pattern which reduces well. Both of these examples have the same grey value, 20%, but one has 60 lines per inch and the other 27.5. On reduction, the dots on the former will run together and produce a dirty smudge whereas the latter will reduce successfully.

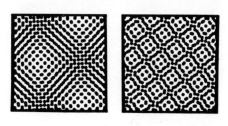

60 lines per inch 27.5

Don't choose pretty styles.

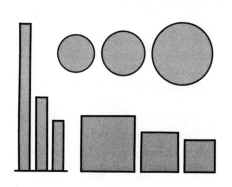

Bars and columns
Avoid using squares, cubes, circles, or spheres – they are too difficult to compare visually.

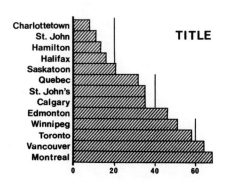

Bars and columns should be wider or narrower than the spaces between them. All bars should be of equal width. When there are many bars, the spaces may be eliminated.

Give all bars a tone. Do not let one bar
or portion be white. Keep the outlines
of equal weight.

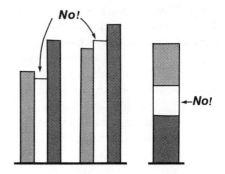

Place the longest bar at the bottom
whenever possible. When the longest
must be at the top, balance the chart
with the title.

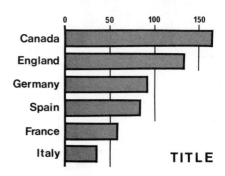

If one bar or column is much longer
than the rest, break it, but break also
the corresponding axis. Place the ac-
tual value in the broken segment.

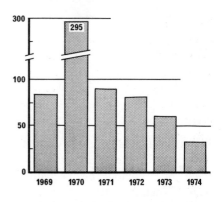

Labelling bars and columns

The use of scale and grid lines makes it unnecessary to give the numerical data in labels. But sometimes the scale can be omitted and actual amounts indicated. Don't place figures or words beyond the ends of the bars or columns, as this creates the illusion of greater length or height and makes visual comparison difficult.

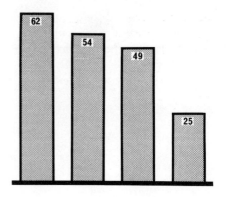

Line up the right end of bar legends with the axis.

With divided bars, place the label for each division either above or below the first bar. A key may be necessary here.

With divided columns, place labels to the left or right.

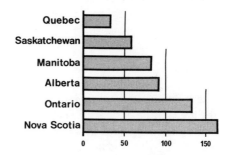

Pie charts

Wherever possible, arrange sectors according to size. Place the largest at the central point of the upper half of the circle and continue with progressively smaller portions in a clockwise manner.

No segment should be less than 5% (18°).

Normally, limit the number of sectors to five.

One segment may be separated to give it extra emphasis, but never separate more than one.

Place labels outside the circle.

Avoid using leader lines, arrows, or keys.

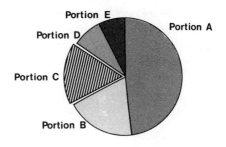

Source

Acknowledgement of the source is usually placed at the lower left corner of the chart.

Use the smallest legible letter size.

Source: Canada Year Book, 1974

ARTWORK

The most important consideration in the preparation of final artwork for publication or projection is that it be legible – easy to read and easy to interpret. *Legibility should never be sacrificed for beauty* – achievement of both is a bonus. Some factors involved are: words (number, size, style, and spacing); lines (width); shape and arrangement of objects and spaces; value and/or colour of background and objects; viewing distance.

Lower-case (small) letters are easier to read than upper-case (capital) letters.

Short titles can be upper case, but if a title has more than five words lower-case letters are preferable.

Number
Individual specifications will be discussed in the next chapter.

Size
Size depends on viewing distance

Style
Choose a legible letter style, preferably sans serif (gothic). These faces are good choices:
Helvetica Medium
Grotesque
Future
Franklin
Folio
Univers (probably the most useful, because there are many different letter weights and widths plus italic).

Faces with serifs are not recommended, because the serifs and thin strokes often get lost on projection or reduction.

Try not to mix styles. A type family like Univers, with its many different weights and widths, is thus recommended. A bold Univers can be used with a condensed Univers or with any other Univers letter as the style is the same. Most of the other faces listed above are quite similar, however, and, in a pinch, can be combined.

Folio Medium

Franklin Gothic

Futura Medium

Grotesque 216

Helvetica Medium

Univers 53
Univers 55
Univers 57
Univers 65
Univers 66
Univers 67
Univers 75

Baskerville

Century Schoolbook

Garamond

Avoid overly condensed or very bold or thin letters.

Compacta Light

Helvetica X-Light

Futura Extra Bold

Spacing
Space letters optically. The word MINOLTA on the left appears to have holes between the L and T and the T and A, even though the distance between them is the same as between the M, I, and N. Space parallel strokes farther apart, round letters closer. Overlap L's and T's, V's and A's, T's and A's.

Between words, allow an *n* of the same typeface. Too much space causes readers to read words rather than sentences. Too little space makes words hard to decipher. Allow two *n*'s between sentences. The distance from the bottom of one line to the bottom of the next should be about 2½ to 3 times the height of an *n*, as this leaves room for extenders. It is better to exaggerate the space than to place lines too close together.

no! yes!

MINOLT A MINOLTA
PLANNING PLANNING
 VA LT TA

Place an 'n' between words. Place 2 'ns' between sentences and 3 'ns' between lines.

34

Here is a useful rule for establishing the weight of rulings and lines. Determine the minimum height of letter (see specifications for individual media). Minor scale lines should be one half the width of a letter *l* in this size. x and y axes will be one *l* wide; curve lines 2 to 3 *l*'s.

3/SHAPE AND ARRANGEMENT OF OBJECTS AND SPACES

Use of some principles of good design can make even the most rigid chart more legible.

Simplicity
Each graphic should present one idea only in an easy-to-read and easy-to-understand style. All extraneous information should be deleted.

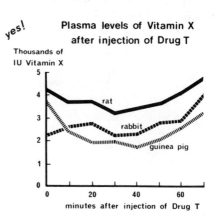

no!

RAT, RABBIT AND GUINEA PIG
PLASMA LEVELS OF VITAMIN X
AT 10 MINUTE INTERVALS
AFTER INJECTION OF DRUG T

yes!

Plasma levels of Vitamin X
after injection of Drug T

Emphasis

By use of size or colour or shape, one element should be made the centre of attention. In a graph, the most important elements are the title and the data. The title has the largest lettering. The curves have the widest line.

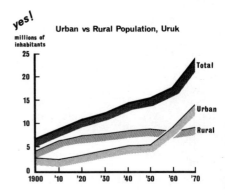

Unity

Each element should function as part of a whole rather than as a separate entity. This can be achieved by grouping elements or by creating obvious similarities of line or shape or colour.

Balance

Elements should be arranged to create an equilibrium. The title or key can often be used to balance an otherwise unstable graphic.

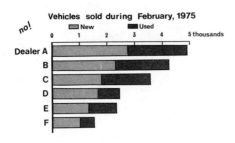

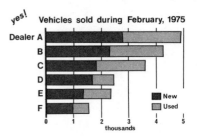

Colour is expensive. Black and white artwork usually is easier and quicker to prepare and cheaper to reproduce, and is generally as effective. When you do use colour, therefore, use it for a specific reason and use it well, never just to make the graphic pretty. Use it to add information or to make an object recognizable, to direct attention, to create emphasis, or to differentiate.

Every colour has three properties: hue, value, and chroma. Hue is the variation of colour as seen in the spectrum, e.g., red, green, violet. From pigments of the three primary hues, blue, red, and yellow, many others can be made. The value or tone of a colour is its lightness or darkness, e.g., light blue or dark blue, and can be compared with the range of greys from white to black. To achieve various values, white or black are added to the pigment. Chroma, or intensity, refers to the brightness or dullness of a colour – yellow has a high chroma, blue has a low chroma. The chroma of a colour can be reduced by adding its complement.

In the planning of any coloured visual, hue, value, and chroma are as important as line, shape, mass, and texture. In well integrated, unified artwork, these seven visual elements – individually and together as a whole – follow the principles of design: balance, dominance, simplicity or limitation, and movement or rhythm.

While conscious application of these principles can strengthen a visual, much good design actually is rather instinctive. Designers spend time reviewing the work of other artists and illustrators and often draw on this pool of experience for ideas about colour schemes or design approaches that can be applied to the job at hand. If an illustration is pleasing, save it. Try to determine what it is you like and then apply it to your own graphics.

All colours, no matter whether they are pure spectral hues, darkened with black, lightened with white, or dulled with their complements, can be compared as to lightness or darkness with a value of grey. In designing graphics for any medium, but especially for television, value contrasts are extremely important – a coloured graphic may be viewed on a black and white monitor or on a badly adjusted colour monitor. As with black and white tone patterns, adjacent colours should have grey value contrasts of at least 30%. Thus, a light blue whose value corresponds with a 10% grey should not be used beside a yellow whose value also corresponds with a 10% grey. If the design depends on such a juxtaposition, the two colours must be separated with a heavy black line.

To determine a colour's grey value, place it beside a grey scale and reduce the room light or squint your eyes until you no longer see colour. Move the colour chip back and forth from grey to grey, one grey at a time, until the values match. Block out all other visual stimuli and focus on the junction of the two colours. Notice that there must be neither a black line nor a

white space between the colour chip and the greys.

When lettering coloured graphics, never place white letters on light backgrounds or black letters on dark tones. Dark, low-chroma letters on a light background are more readable than light, high-chroma ones on dark. The most legible colour combinations are:

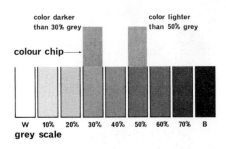

Lettering or art	Background
Black	Yellow
Black	White
Dark green	White
Dark blue	White
White	Dark blue

Where possible, let the most important item in a graphic have the most important colour and the greatest contrast with its background. 'Important' colours are those with high intensities and are at the light end of the value scale. The pure hues – green yellow, yellow, yellow orange, orange, and orange red, all warm colours – are considered more attention-getting, especially when used in moderation and when placed against a darker colour of low chroma. Warm colours seem to advance while cool colours – red violet, violet, blue, and blue green – recede and should be reserved for backgrounds.

Avoid placing complementary colours of the same value adjacent to each other. They appear to vibrate and annoy the viewer. In other uses, this can be a most effective device but is not recommended for teaching visuals.

Avoid creating large areas of white. On slides or TV, white, especially when contrasted with dark colours or black, flares and is hard to look at.

When preparing maps or other graphics in which colours represent numbers of items, try to graduate values from light to dark as the number increases. For example, one to ten items may be shown as white, ten to twenty as yellow, twenty to thirty as light orange, and so on. This is not always possible, however, when adjacent areas would be given adjacent values: tones would be too similar.

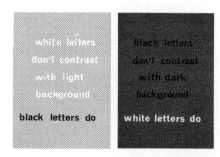

white letters don't contrast with light background — black letters do

black letters don't contrast with dark background — white letters do

38

3

Media specifications and artists' aids

Graphics may be wanted for any one of many media. While print continues to be the medium of lasting publication, the same material may be used for display on television, or to accompany lectures in the form of 35 mm slides, overhead transparencies, films and filmstrips, or flip charts. Good graphic design involves the same elements in all these media, but each has its own special requirements, and these are the subject of much of this chapter. The proportions of a graphic are determined, for example, by the proportions of the TV screen, 35 mm slide, overhead projector, or printed page. The medium also determines how many words can be incorporated with graphic material, and how large the lettering should be. Ignoring the 'givens' in each medium will inevitably mean reduced impact, if not illegibility.

One useful device, I have found, is a cardboard template, cut to the required dimensions. Examples are illustrated on the following pages for television and slides. The template should be lettered to show the medium, dimensions, and minimum letter size. An array of these will greatly facilitate the preparation of consistent, correctly proportioned graphics.

For do-it-themselves graphic artists, the chapter ends with a list of some materials that can be purchased at most art stores to make the task easier.

The proportion for TV *graphics is always 3 units high × 4 units wide.* A nice size to work with is 22.5 × 30 cm, but this is arbitrary.

On the template – or on your artwork – subtract a margin ¹/₆ the height and the width from the top, the bottom, and both sides, and keep all important information within this reduced 'working space.' This margin is important because receiving monitors cut off various amounts of the borders.

In particular, when a 35 mm slide prepared in the usual manner is used for TV transmission, a part of the normal viewing area is not transmitted. Of course, the long side of the slide should be horizontal.

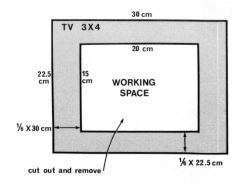

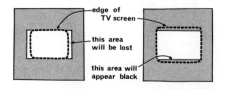

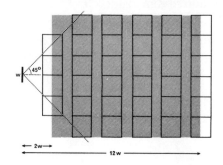

The recommended maximum viewing distance for TV is 12 × the horizontal measurement of the screen. The minimum distance is 2 ×. The viewer should be within a 45° angle from a perpendicular to the screen. For critical work, a smaller angle (30°) is preferred.

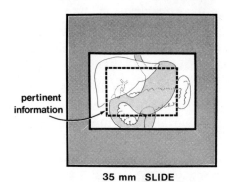

The minimum letter size, based on the recommended maximum viewing distance of 12 w, should be $1/20$ the height of the graphic. To determine this ratio, measure the height of a lower-case n.

Titles should be twice the height of the minimum letter.

When preparing artwork for projection or TV knowing that viewing distances will be greater or less than those recommended, the ratio of height of letter to height of artwork should be increased or decreased. When the viewing distance increases, the size of minimum letter should also increase.

The minimum line width is one half the width of a lower-case l in the minimum letter size.

An effective TV graphic can carry only a limited number of words. A good maximum is 10 lines of text with 24 characters per line (including spaces). It is better to have 6 lines with a total of 20 words.

A typewriter can be used to prepare graphics for TV quickly. But rules for dimensions must be followed accurately if the typing is to be readable when broadcast. The height of the graphic should be 20 × the height of the lower-case n on the machine used; the width will then be $4/3$ the height.

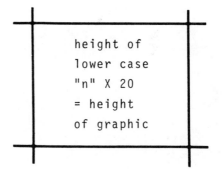

Distance in widths of image on the screen	Ratio of height of letter to height of artwork
4 w	1/75
6 w	1/50
8 w	1/35
10 w	1/30
12 w	1/20

height of
lower case
"n" X 20
= height
of graphic

Artwork must always be prepared within a frame 2 units high by 3 units wide. This may be 20 × 30 cm or 10 × 15 cm or any other convenient size. The actual size is indicated on the artwork by crop marks – guides for the photographer. Again, for safety, allow a margin of 1 or 2 cm per side and see that all pertinent information is within this 'working space.' For a quick check, view the artwork from an appropriate distance through an empty slide mount.

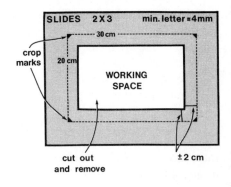

Always prepare artwork to fill the 2 × 3 format. If a square or round chart is to be drawn, use the title to balance the space. In these two slides, the artwork for the graph is exactly the same size, but in one the available space has been used economically; in the other, the information will be relatively smaller when projected.

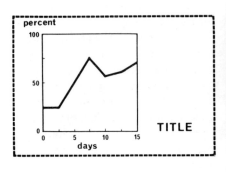

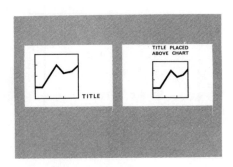

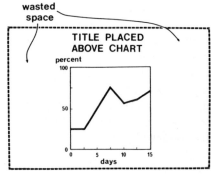

The recommended maximum viewing distance for projected materials – slides, films, filmstrips, and overhead transparencies – is 6 × the horizontal measurement of the image on the screen. The optimum distance is between 2 × and 6 ×. Viewers should be within a 30° angle from a perpendicular to the screen.

In rear screen projection the image quality is reduced, and the recommended viewing distance and angle are accordingly less.

As with TV, when viewing distances are known to be greater or less than 6 ×, the ratio of letter height to graphic height varies.

A quick check to determine whether or not your artwork will be legible is to hold it 6 × its width (or 12 × or 4 ×) from you. If you can read it with the unaided eye, then it will be readable on projection. Hold 35 mm slides away 6 × their horizontal measurement, i.e., 22 cm (8½ inches).

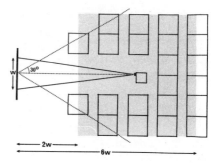

The minimum height of lower-case letters, based on the recommended maximum viewing distance of 6 w, is ¹/₅₀ the height from crop mark to crop mark. In our example it is ¹/₅₀ × 20 cm = 4 mm.

Titles should be 2 × the minimum.

Maximum number of words: 10 lines of 24 characters per line (including spaces). The ideal is 6 lines with a total of 20 words.

The minimum line width is ¹/₂ the l of the minimum letter size.

Typewriters can also be used in making 35 mm slides. The dimensions for typewriter copy depend on the size of type on the machine. Measure the height of the small letter n and multiply by 50 to determine the maximum height of the graphic. Width = height × ³/₂.

Titles are always 2 × the minimum size. Therefore, height of copy for title slides will be 25 × height of the letter n.

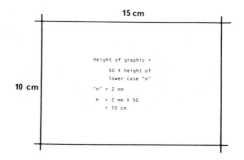

Use any machine with a gothic or sans serif letter rather than a serifed face. Use a carbon ribbon. For extra blackness, place a sheet of carbon paper face up behind the paper so that the carbon is printed on the reverse side of the paper, or type each line twice. Use a good-quality bond paper or file cards.

Slides produced by typewriter do not necessarily have to be black on white, but the background colour must be light enough in tone that it will contrast well with the type. Brighter colours like yellow, gold, or orange are easier to photograph. Pale blues and greens seem to wash out.

Negative slides, with white words on a black background, can be made, but the viewer is apt to suffer eye fatigue. They should be used only in a semi-illuminated room. If negative slides are to be used, glare can be avoided by covering the entire slide with coloured adhesive acetate. In a slide with a series of words, cover the important word with one colour, e.g., yellow, and the other words with a second colour, e.g., blue. A broad-tipped felt pen can also be used to colour negative slides, or commercial dyes can be used in the developing process to colour the words.

Diazo transparencies can be prepared from negative slides. In this kind of transparency, diazochrome salts and colour couplers are coated on transparent acetate film. If this coating is developed in ammonia fumes or other alkaline medium, the diazo salts and couplers unite to form a transparent colour. If the coating is first exposed to

GOTHIC type

SERIFED type

ultraviolet light, then developed, no image will appear. With this process it is possible to prepare 35 mm slides (or overhead transparencies) using as a master a high contrast negative or an ink drawing on translucent paper: those areas of the original which block the passage of ultraviolet light will be coloured while those areas through which the light passes will be colourless. The most common colour combination is white words on a blue background. Diazo slides fade rapidly, but can be partially restored to colour by re-exposing them to ammonia vapour.

Permanent slides with coloured backgrounds can be prepared by exposing colour film to a negative high-contrast transparency (white words on black) and then re-exposing them through a colour filter.

3/ OVERHEAD TRANSPARENCIES

Artwork for overhead transparencies is usually prepared full size. This size depends on the methods used for reproduction and for mounting. Generally it is $7^{1}/_{2} \times 9^{1}/_{2}$ inches (19 × 25 cm).

Recommended viewing conditions for overhead transparencies are as for slides, with the maximum distance 6 × the horizontal measurement of the image on the screen.

The minimum height of lower-case letters, based on the maximum recommended viewing distance, is $^1/_{50}$ the height of the graphic = 4 mm. When viewing distances are known to be greater or less than 6 ×, the ratio of letter height to graphic height varies.

Titles should be 2 × the minimum = 8 mm.

Maximum number of words: 10 lines of 24 characters per line (including spaces). The ideal is 6 lines with a total of 20 words.

Minimum line width is 1.5 mm. Major lines should be about 3 mm.

Typewriters with upper-case type of 3.8 mm are available and can be used for the rapid preparation of adequate but not ideal transparencies. They are not highly recommended, however, as they have several drawbacks: the 3.8 mm size is achieved only by upper-case characters, which are not so easily read as lower-case characters; the strokes of the letters are thin; the letters are not spaced optically.

4/ FILMS AND FILMSTRIPS

The proportion for 8 mm, super 8 mm, and 16 mm films and for single-frame filmstrips is 3 high × 4 wide. The proportion for double-frame filmstrips is 2 high × 3 wide.

The recommended viewing conditions for films and filmstrips are as for slides.

The minimum height of lower-case letters, based on the recommended maximum viewing distance of 6 w, is $^1/_{50}$ the height from crop mark to crop mark.

dry – transfer letter height 4.0 mm

TYPEWRITER HEIGHT OF
UPPER CASE LETTER 3.8 mm

Titles should be 2 × the minimum.

Maximum number of words: 10 lines of 24 characters per line (including spaces). The ideal is 6 lines with a total of 20 words.

Minimum line is $^1/_2$ l.

5/ NON-PROJECTED VISUALS

This category includes all displays and flip-charts. The size of the lettering depends on the proposed viewing distance. The following is a guide:

Maximum viewing distance	Minimum letter height
8 ft (2$^1/_2$ m)	$^1/_4$ inch (7 mm)
16 ft (5 m)	$^1/_2$ inch (1$^1/_2$ cm)
32 ft (10 m)	1 inch (3 cm)
64 ft (20 m)	2 inches (6 cm)

Each journal has its own specifications for artwork.

Generally, graphics are prepared at least 2¹/₂ times larger than they will be reproduced, in order to give the artist more freedom in preparing them. But this means that *all words, tone patterns, and patterned tapes must be able to be reduced in size and yet remain legible.* For this reason, very bold or very light styles of type, and tone patterns with a closed dot, must be avoided.

Reduction often makes the difference between tone patterns undistinguishable. Make sure that tone values contrast well.

Before artwork is submitted to the publisher, it can be checked for readability and distinct tone patterns by having a photograph or photostat made, reduced to the width of a journal or book column.

The number of words in published material is not critical. And, since the reader can easily turn the book, labelling of the y axis can be vertical.

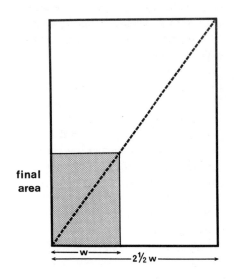

GRAPHIC AIDS

Many aids to graphic makers are commercially available. While they are expensive, their use can enhance any graphic and save the artist much time. They are available at most art supply stores.

1/ TAPES

Tapes come in all widths from ¹/₆₄ to 1 inch and in a wide variety of colours and patterns.

Transparent tape is useful for adding colour directly to overhead transparencies.

Opaque tape comes in two kinds, glossy and matte. The glossy tape is good for display work, but matte tape should always be used for work to be photographed.

Mistakes are easier to correct when black matte tapes are used instead of black ink. Use flexible tape for curved lines and non-flexible tape for all

straight lines. Simply pull out the tape, press it down, and cut it off with a knife. (A sharp x-acto knife or scalpel with no. 11 blade is a must for the graphic maker.)

2/ COLOURED PAPERS

A wide selection of coloured papers is available – one manufacturer boasts 500 colours. They are light-weight and have either matte or glossy surfaces: matte surfaces should be used for all work to be photographed.

Papers can be cut and pasted down, in collage fashion.

Coloured papers can be used for typing; since they show erasures, however, it is best to type the corrected word on a patch and paste it over the error. It's wise to run a felt-tip marker of the same colour over the white cut edge before pasting.

3/ COLOURED BOARDS

A wide range of colours is also available in medium-weight matte-surfaced board. One manufacturer has 55 colours in board and matching papers, and these make ideal backgrounds for artwork for both slides and TV.

Rubber cement stains most matte boards: either apply it evenly to the whole board and then remove the excess or apply it with extreme care to designated areas only.

4/ COLOURED ACETATE OVERLAYS

The manufacturer of the 500 coloured papers has 192 of the same colours in self-adhesive acetate overlays.

Another has 228 colours. The overlay material is a coloured film stuck to a white waxed backing sheet. To use it, place the whole sheet – backing and film – over the artwork. With a very sharp knife cut the acetate, not the backing, around an area slightly larger than that to be coloured. Then peel the acetate away from the backing and press it on to the artwork, to which it will adhere. With the knife, trim away excess film and burnish the surface lightly.

Use transparent film for overhead transparencies.

5/ TONE PATTERNS

A wide range of patterns is commercially available. They are similar in form to the coloured acetate overlay sheets, and are applied in the same way.

6/ FELT-TIP PENS

A wide range of colours and points is available. For overhead transparencies, use markers especially labelled 'For acetate or overhead projection'; their inks can be washed off with water or alcohol. Make sure the line width is 1.5 mm (slightly less than $1/16$ inch).

7/ GLUES

Stick glue is available in two sizes. It is very strong, almost permanent, and, because of its form (like a lipstick), easy to use.

Pressure-sensitive spray adhesives are ideal for both temporary mounting and permanent bonding of art-

work, but must be used with caution because of the fumes.

To apply rubber cement for an almost permanent bond, spread the cement evenly over the background and the back of the paper to be glued, using a spatula or straight edge of cardboard, and let it dry thoroughly. Then place a piece of tissue or tracing paper between the two glued papers until they are in the correct position, and join a narrow strip of the two glued papers at one edge. Gradually remove the tissue, smoothing down the two papers at the same time.

8/ DRY TRANSFER LETTERS

Many styles of type in complete ranges of sizes are available in both black and white. Some styles are also produced in colour. For overhead transparencies, use coloured transparent letters.

In lettering with these materials (of which Letraset is perhaps best known), first lay down a strip of masking tape or tape down a piece of paper as a line guide. On white backgrounds, simply draw a blue line: because high-contrast film is not sensitive to blue, the line will not need erasing.

An error in lettering can be lifted with tape. If a whole word is badly placed, gently press Scotch Brand Magic Transparent tape over the word, carefully lift the tape with the word stuck to it, and reposition it. Trim off the excess tape, then burnish. This tape technique can also be used to centre titles quickly.

9/ LETTERING GUIDES

With practice, fast, high-quality lettering can be produced with template lettering guides.

Leroy, consisting of templates, scriber, and pens, is the most common.

Varigraph, a similar system, uses a scriber which can vary the height and/or width of the template letter. One template, therefore, can produce a wide size range. Many letter styles are available.

Simple plastic stencils are also available.

Leroy

template 350

template 200

Varigraph 904

48

4

Choosing illustrations

Illustrations – drawings, paintings, charts, maps, or photographs – are an essential part of publication. Too much graphic material, however, will reduce its own impact. For this reason, and because illustrations are costly to reproduce, in both dollars and space, they must be chosen carefully to enhance the text.

In what follows we will consider the selection of illustrations, the qualities of a good photograph, and the submission of photos to a publisher.

SELECTING ILLUSTRATIONS
How do you decide whether to use a photo or a graphic, a table or a chart? First ask what it is you wish to illustrate or emphasize, what aspect is important. How many visual characteristics are necessary to get this point across? Each form of illustration has advantages and disadvantages – no single form can solve all problems. The following are some of the uses of the more important types of illustrations.

Photographs may be used to present scientific proof and authentic recording, illustrate actual colour or tonal and textural detail, add aesthetic appeal, or create a mood.

Drawings and paintings have one major advantage over many photographs: they control the viewer's perception by showing only essential details and omitting anything unnecessary. As a result, they emphasize important points, relationships, and differences by altering scale, contrast,

49

or colour. They may be used to simplify shapes, or to accentuate a three-dimensional depiction by presenting hidden parts or details in exploded views. They can also indicate direction of flow or order of sequence, and prompt subliminal or psychological responses.

Charts, graphs, and diagrams are best employed to display trends or magnitudes or relationships of data, clarify complicated or involved ideas, and explain functions or operations.

Before submitting illustrations of any kind to a publisher, examine each carefully and ask:

1/ Is this illustration relevant or is it merely 'cute' or faddish?

2/ Does it add information or does it duplicate verbal material? If the latter, is this redundancy desirable or necessary to reinforce an important idea?

3/ Does it present too much or too little information? (Limit information to one subject per illustration.)

4/ Is it clear and easy to understand? Ask a third person if he can interpret the illustration. Would a different view or approach be better?

5/ Would another form of illustration better express the intention – a drawing rather than a photo, a diagram rather than a chart?

6/ If it has to be reduced for publication will it lose too much detail? Reducing lenses – the opposite of magnifying glasses – are useful for checking. If the illustration is a slide, on the other hand, check whether it will enlarge well, or will faults merely be magnified?

7/ In the case of drawings, charts, graphs, and diagrams, is the artwork of high quality, or is it 'make do'?

8/ If your illustrations are photos, do they all have consistent lighting, background, scale, etc.? Are they good technically?

For drawings, charts, and maps, while most publishers prefer to receive original work, some will accept photographic copies. These, like any other photographs, must be of high technical quality.

WHAT IS A TECHNICALLY GOOD PHOTOGRAPH?
Many authors are so familiar with travel or family photos produced from small, cheap instant cameras that they have become immune to their inadequacies. The lenses and mechanics of such cameras simply cannot compare with those of professional models; as a result, home photos are seldom acceptable for publication.

Note, too, that photographs taken from a book or article cannot be

satisfactorily reproduced and are, therefore, unacceptable. These photos have already been 'screened' or broken into a dot pattern for the original publication, and when they are reprocessed the new picture is of poor quality. Often it has a moiré pattern (something like a tartan) across it.

The ideal photograph has at least these technical qualities:

1/ precise focus, sharp outlines, clear details, and no peripheral aberrations (i.e., no loss of focus on the periphery);

2/ a good range of tones from very dark to very light with detail in both shadows and highlights – in photos of people, scenes, or things that will be reproduced as halftones;

3/ distinct contrast – in photos of line drawings (blacks should be black with no skipping or blurring, and whites should be white);

4/ subjects that are easily recognizable;

5/ content that is the minimum necessary, with no extraneous details;

6/ background that is plain and uncluttered with no distracting elements (if the background is unavoidably 'busy' it should be made less obvious by lighting, focusing, or darkroom skill);

7/ a background tone that contrasts with and enhances the subject;

8/ a scale or known object for size comparison (a standard measure, such as a ruler, is common in scientific pictures, but for other purposes any familiar object will provide scale).

In addition, attention to content and composition is necessary to produce photos that are well designed and interesting.

To ensure that the quality of photos is as good as that of the text, it's wise to consider employing a professional photographer. He has good equipment and knows how to use it to its maximum value. He will choose a lens, filter, focal length, camera angle, aperture, and shutter speed to enhance the subject and to emphasize or downplay specific features as desired. He knows many ways to light the subject to achieve different effects or minimize shadows, and he knows the type of background which will look best. He is intimately familiar with the wide variety of films on the market and will use the one best suited. He can even control the processing to enhance the subject or produce special effects. For a series of photos, the professional photographer will ensure that each has the same background, lighting, camera angle, and distance so that each will have a similar appearance, tonal range, and size. He will ensure that all photos are shot with the same type of film and that processing and handling are consistent.

Because photographers are expensive, many authors balk at the cost. However, if work is well planned and carefully organized in advance, and if all unnecessary shots are eliminated, the extra cost can be kept at a minimal and well-justified level.

When preparing a budget, researchers should allow one to two per cent for the preparation of graphics and their reproduction.

SUBMITTING PHOTOS TO A PUBLISHER

Colour vs black and white
The cost of printing full-colour photos is very high compared with that for black and white. Many publications expect authors to bear all or part of this extra cost. Ask yourself if the additional expense is justified. Is colour necessary in the identification or differentiation of objects? Does it create a mood? Is background colour a necessary key to location or content? If colour is not essential for clarity, a good black and white photo will communicate the message as effectively.

Colour prints vs transparencies
For reproduction in colour, most publishers prefer to work with 2 × 2-inch or 35mm colour slides rather than with colour prints. The best rule is to submit the original, be it slide or print.

Any slide must necessarily be enlarged for publication. Therefore, when composing a picture to be reproduced from a slide, fill the frame with the subject so that the amount of enlargement will be as little as possible. Make sure that focus is sharp and that there is a good tonal gradation. Protect transparencies from scratches or fingerprints by mounting them in glass or enclosing them in a translucent envelope.

Adequate black and white prints can be made from 35mm colour slides but they are rarely totally satisfactory. If reproduction is to be in black and white, an original colour print may be preferable to a slide.

Black and white photos
Every publisher has his own specifications for illustrations. Some ask for 5 × 7-inch glossy prints, unmounted. Others want 3 × 5-inch mounted photos. Still others make no mention of size or quantity. The following are generally safe rules to follow when submitting photos to publishers, except when a publisher has specifically requested otherwise in his instructions to contributors.

Size
Prints should be 8 × 10-inch or 5 × 7-inch. In a series, all photos, and all subjects within the photos, should be approximately the same size so that each will have a common reduction and a final consistent size.

Finish and colour
Always submit glossy or near glossy prints. Photostats (PMT's – photo mechanical transfers – not quick paper copies) of line work are acceptable. Not acceptable, however, are matte or textured finishes, e.g., 'silk' finish.

Blue-black black and white photos are preferred to ones with a brown-black hue.

Protection
Each photo must be protected from fingerprints. Use either plastic covers of the type used in photo albums – ideal for this purpose – or a translucent overlay affixed with masking tape to the back of the uncropped photo. The overlay may be a heavy tracing paper or other strong see-through paper.

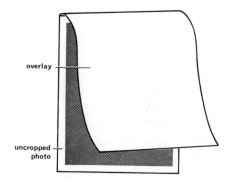

Mounting photos
Most publishers prefer to receive unmounted photos. For those who do prefer mounted photos, however, cut the backing so that it has borders of 3 inches around the photo. Use dry mount tissue or rubber cement, never a water-based glue which will wrinkle the photo. Affix transparent acetate to protect the photo and a translucent overlay.

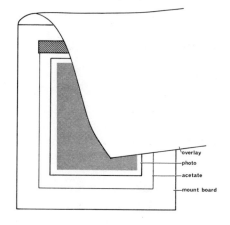

53

Handling photos

Always handle photos by the margins. Fingerprints can damage the emulsion and become a permanent part of the print and therefore of the final published photo.

Identifying photos

Each photo must be labelled with its number, the author's name, and the publication. Too often, when writing on the back, authors damage photos by pressing too heavily. Never use a ball point pen. Write lightly with a very soft pencil or felt marker, making sure the photo is on a hard surface. Test the marker – it may bleed through to the other side. Or it may not dry quickly and then will smear onto the next photo in a stack.

New resin-coated photographic papers present special problems. Most markers and pencils won't write on them. Pressing harder merely damages the emulsion on the other side. Use grease or 'china-marking' pencils, or stick a label on the back and write on that.

A better way to label photos is with a tab on which number, name, and journal can be written. Use the self-stick kind of label, folded over, and write with a permanent, smear-proof marker.

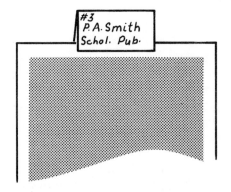

Instructions for the editor
If a photo is to be reproduced most
effectively from the author's view-
point, the editor must know what is in
the author's mind. The standard way
to submit this information is to affix
an overlay to the photo and write on
it. Unless extreme care is taken, how-
ever, the photo can be damaged by too
much pressure on the overlay, or
markers can bleed through and stain
the photo. A better way is to photo-
copy the original photo, write all in-
structions on the copy, and submit
that with the original photo.

The editor needs to know:
1/ The final size you desire, e.g., 1
column or 1 page.
2/ The important area of the photo:
circle it on the copy or overlay.

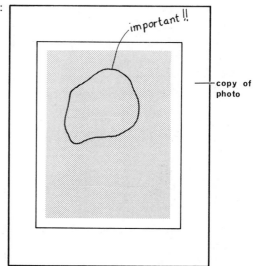

3/ Where to crop, i.e., what can be
omitted along the edges. Most pub-
lishers prefer photos which can be
cropped slightly rather than photos
trimmed by the author to exact size.
This gives the publisher some leeway

when preparing layouts, or will let him correct slanting horizons or leaning buildings. Indicate any unnecessary parts of the photo with 'crop marks' on the overlay, or with grease pencil on the borders of the photo. Better, of course, is to mark a photocopy.

4/ Which way is up. If there is any room for doubt – and what may be obvious to the author may not be to an editor, production person, or compositor – the right place on the photo should be labelled 'TOP.'

5/ Arrows, words, and numbers that must be added to the photo. Most publishers prefer to typeset words or numbers which are to appear on the photo so that a consistent style can be used throughout, and so that words will be legible regardless of the final reduction of the photo. Specify the exact locations on the overlay or

56

photocopy. Overlays do occasionally become mispositioned and words to be typeset end up in the wrong place: avoid this by placing register marks at the corners of both photo and overlay.

Remember, whenever writing on the overlay, to protect the face of the photo with a piece of cardboard between the photograph and the overlay.

Labelling photographs

Hand-drawn arrows or letters on actual photographs are never acceptable. If this is a job for the author rather than the publisher, use dry-transfer lettering and symbols like Letraset. Choose either white or black to contrast well with the background. Always pre-burnish the symbol on its waxed backing sheet before transferring it onto the photo: this allows the letter to be transferred with much less pressure and thus less damage to the photo. Because dry-transfer letters are very fragile and come off easily, it is a good idea to mark also the protective overlay or photocopy. To ensure that numbers will always be visible, first lay down a dry-transfer square or circle and then place a symbol of opposite colour onto it, or use the equivalent dry-transfer combination.

Scales

In scientific photographs, include a scale or micron rule in the photo itself; do not put it in the caption or send it separately. Then when the photo is enlarged or reduced, there will be no possibility of mistake.

Numbering

Number all photos consecutively, even when several will be grouped together. Thus, 1, 2, 3, 4, 5, 6, 7, etc., is correct, but 1a, 1b, 2a, 2b, 2c, 3a, etc., is not. Key illustrations to the text by writing each photo number in the margin of the typescript opposite the related passage.

Grouping

If photos are to be grouped, enclose a diagram of the desired positions and order.

Retouching

Retouching of scientific photographs is seldom advised, especially when the photo is offered as proof or for identification. When veracity is not crucial, competent retouching can often clarify or simplify the content.

Any photos which have been retouched must be especially protected. Opaque retouching materials often flake off.

Captions

Prepare a list of captions numbered in the same way as the photos. Include the photo credits, i.e., the source of the photo, in the caption.

Copyright and permission

Written permission must be obtained from the copyright owner of photographs that have been previously published or are otherwise in copyright, or from the owner (as in the case of an historical collection held by a museum). For medical photographs of identifiable patients, written permission must also be obtained. The author is responsible for securing permission.

Mailing to publisher

Never use paper clips or staples, which will dent the emulsion. Place each photo inside a plastic folder or protect the face of each with an overlay. Stack the photos face up and cover the stack top and bottom with heavy cardboard, cut slightly larger than the photos. Enclose the list of captions.

Keep extra numbered prints on file with the corresponding list of captions.

5

Selected references

CHARTS AND GRAPHS

SPEAR, MARY ELEANOR. *Practical Charting Techniques*. New York: McGraw-Hill Book Company, 1969
Everything you need to know about the production of statistical graphics for almost every use

LOCKWOOD, ARTHUR. *Diagrams*. London: Studio Vista, New York: Watson-Guptill, 1969
A visual survey of graphs, maps, charts, and diagrams for the graphic designer

MURGIO, M.P. *Communications Graphics*. Van Nostrand Reinhold Company, 1969
A comprehensive guide to conceiving and implementing visual communication

HERDEG, WALTER, ed. *Graphis Diagrams*. Zurich: The Graphis Press, 1976
A collection of charts and diagrams to illustrate effective graphic visualization of abstract data

NEURATH, M. *Otto Neurath and Isotype*. Japan: Graphic Design, 1973

NEURATH, O. *International Picture Language*. London: Kegan Paul, 1936
The development of an international system of pictographs, by the father of iconic representation

HUFF, D. *How to Lie with Statistics*. New York: W.W. Norton & Company, 1954
A primer in ways to use statistics to deceive

MEYERS, CECIL H. *Handbook of Basic Graphs: A Modern Approach*. Encino, California: Dickenson, 1970

MACDONALD-ROSS, MICHAEL. 'How numbers are shown,' *AV Communication Review*, vol. 25, no. 4, winter 1977
A review of research on the presentation of quantitative data in texts

SIMONDS, D. 'Medical chartist's dilemma,' *Medical and Biological Illustration*, 1976, vol. 26, pp. 153–8
An attempt to spell out standards for artists and chartists

GRAPHIC ARTS

GARLAND, KEN. *Graphics Handbook.* New York: Reinhold Book Corporation, 1966
Supplies the basic facts which make up the essential background of the graphic designer
MUNDAY, P.J. and H. TEMPEST RADFORD. 'Illustration preparation and reproduction
techniques – the publishers' needs,' *Medical and Biological Illustration*, 1976, vol. 26,
pp. 111–14
The planning of illustrative material for economic reproduction in books, journals, and
other publications
Legibility – Artwork to Screen. Pamphlet S-24. Rochester: Eastman Kodak Company
CARLSEN, DARVEY E. *Communication: Graphic Arts.* Englewood Cliffs, N.J.: Prentice-Hall,
Inc., 1976
Includes such information as major printing processes, measurement, graphic arts materials
and techniques, planning for reproduction and production, and finishing operations
BOWMAN, WILLIAM J. *Graphic Communication.* New York: John Wiley & Sons, Inc., 1968
The language, design methodology, and practical substance of graphic communication
ELLINGER, RICHARD G. *Color Structure and Design.* Scranton: International Textbook
Company, 1963
A very practical book on colour composition, complete with exercises, designed to lead the
artist to an understanding of the resources and expressive potentials of colours

AUDIOVISUAL MEDIA, General

KEMP, JERROLD E. *Planning and Producing Audiovisual Materials*, 3rd ed. New York:
Thomas Y. Crowell, 1975
A general text book dealing with basics of production and use of AV material and equipment
BROWN, J.W., R.B. LEWIS, and F.F. HARCLEROAD. *A-V Instruction: Technology, Media and
Methods*, 5th ed. New York: McGraw-Hill Book Company, 1977
A general text on preparing and using all kinds of AV equipment and materials in formal
education
Planning and Producing Visual Aids. Pamphlet S-13. Rochester: Eastman Kodak Company
Artwork Size Standards for Projected Visuals. Pamphlet S-12. Rochester: Eastman Kodak
Company
FLEMING, MALCOLM I. *Perceptual Principles for the Design of Instructional Materials.* U.S.
Department of Health, Education, and Welfare, Office of Education, Bureau of Research,
Project 9-E-001, 1970
Principles and generalizations for instructional designers derived from an analysis of recent
behavioural science and media research literature
GUIMARIN, SPENCER. *Lettering Techniques.* Austin: Visual Instruction Bureau, Division of
Extension, University of Texas. 'Bridges for Ideas' series
Illustrates many types of mechanical, stencil, and spray lettering techniques
MINOR, ED. and HARVEY R. GRYE. *Techniques for Producing Visual Instructional Media.* New
York: McGraw-Hill Book Company, 1970
Techniques, methods, and processes for creating and producing modern instructional media
LINKER, JERRY MAC. *Designing Instructional Visuals: Theory, Composition, Implementa-*

tion. Austin: Instructional Media Center, University of Texas at Austin, 1968. 'Bridges for Ideas' series
Deals with design requirements for production of efficient instructional visuals
WRIGHT, ANDREW. *Designing for Visual Aids*, New York: Van Nostrand Reinhold Company, 1970
A detailed description of various visual media and tips on designing them

TELEVISION
PAUL, DELORES. *A Discussion of Television Visuals*. St Paul: Magnetic Products Division, 3M Company
A very brief booklet containing some basic points about graphics for TV
SPEAR, J.H. *Creating Visuals for TV*. Washington: Division of Audiovisual Instructional Service, National Education Association
Some techniques for improving quality of educational TV
HALAS, JOHN. *Film and TV Graphics*. New York: Hastings House, 1968

35MM SLIDES, FILMSTRIPS, AND FILM
Effective Lecture Slides. Pamphlet S-22. Rochester: Eastman Kodak Company
Slides with a Purpose for Business and Education. Pamphlet VI-15. Rochester: Eastman Kodak Company
Producing Slides and Filmstrips. Pamphlet S-8. Rochester: Eastman Kodak Company
Reverse-Text Slides. Pamphlet S-26. Rochester: Eastman Kodak Company
Basic Titling and Animation. Pamphlet S-21. Rochester: Eastman Kodak Company
LORD, JOHN. *Handbook for the Production of 35 mm Sound Filmstrips*, 3rd ed. St Charles, Illinois: DuKane Corporation, 1971
Provides the technical data necessary to produce 35 mm filmstrips
SNOWBERG, RICHARD LEE. 'Bases for the selection of background colors for transparencies,' *AV Communication Review*, vol. 21, no. 2, summer 1973, pp. 191–207
A controlled study to determine what background colour should be used on projected materials to meet the legibility needs of the viewer

OVERHEAD TRANSPARENCIES
A Guide to More Effective Meetings. Pamphlet. St Paul: Visual Products Division, 3M Company
ADAMS, SARAH, et al. 'Readable letter size and visibility for overhead projection transparencies,' *AV Communication Review*, winter 1965, pp. 412–17
A Guide to Overhead Projection and Transparency Making. Pamphlet. Holyoke, Mass: Scott Graphics

JOURNALS

Educational Communication and Technology – A Journal of Theory, Research and Development. Association for Educational Communications and Technology, Washington, DC
Theory, development, and research related to technological processes in education. Quarterly

Audiovisual Instruction. Association for Educational Communications and Technology, Washington, DC
The use of technology in educational situations. Ten times a year

British Journal of Educational Technology. Council for Educational Technology for the United Kingdom. Councils and Education Press Ltd.
Theory, applications, and development of educational technology and communications

Index